MATRIX

A VISIT WITH MAGRITTE BY DUANE MICHALS

If I indulge myself and surrender to memory, I can still feel the knot of excitement that gripped me as I turned the corner into Rue Mimosas, looking for the house of Rene Magritte. It was August, 1965. I was thirty-three years old and about to meet the man whose profound and witty surrealist paintings had contradicted my assumption about photography.

An introduction was made by a friend of a friend who was writing a book about Magritte and had lived in his home in Brussels. It seemed peculiar to me that anyone might actually know Magritte. Artists and poets I admire always seem to be not real. They are like fictional characters who exist only in printed pages or as paintings on walls. On the other hand, traditional celebrities like movie stars are too accessible. We know exactly what they look like and grow bored by the glut of information about their activities. Although some painters are more celebrities than artists, those rare mythical ones are different. Their art appears here and there like gifts left by an unseen Santa Claus. Magritte's art was a great gift to me. I knew nothing about him and was curious what sort of man could produce this work. I had no idea what he looked like and realized that I might pass him on the street unaware.

When I pushed the buzzer by the name Magritte, I was not totally sure why I was there. I felt awkward, like a sixth grader about to enter the principal's office. During the entire visit I felt like that, awkward and silent. Not just because my French was as bad as his English but silent in the way we are around those of whom we are in awe; intimidated by our respect for them, and so pleased to be there that we don't want to jeopardize our dream of being there. It was a privileged moment.

Being older, I understand a little better, I know that there are some few people in our lives who are great givers, not just mentors in the usual sense. They open our lives, give without taking, and free us in the process. They do this unbeknownst. They do it by the example of their lives and in the power of their art. The power and integrity of Magritte's vision had brought me there to thank him.

What had so engaged me in Magritte's work was its ability to perplex. In his world, I could not be sure of anything. Giant roses filled entire rooms, the moon lit up a starry sky at midday and nightgowns could display real woman's breasts. In his paintings he presented such amusing but serious ideas. I was freed from just looking.

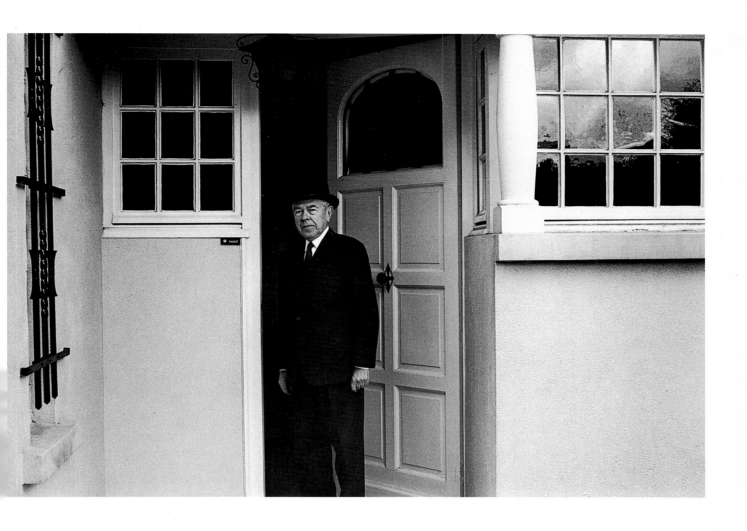

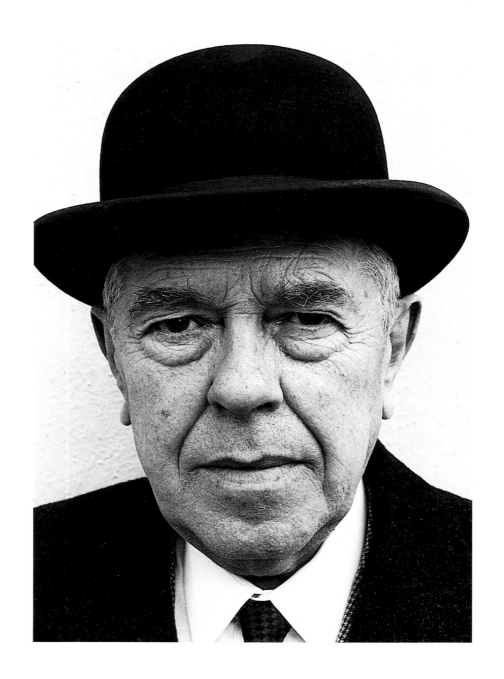

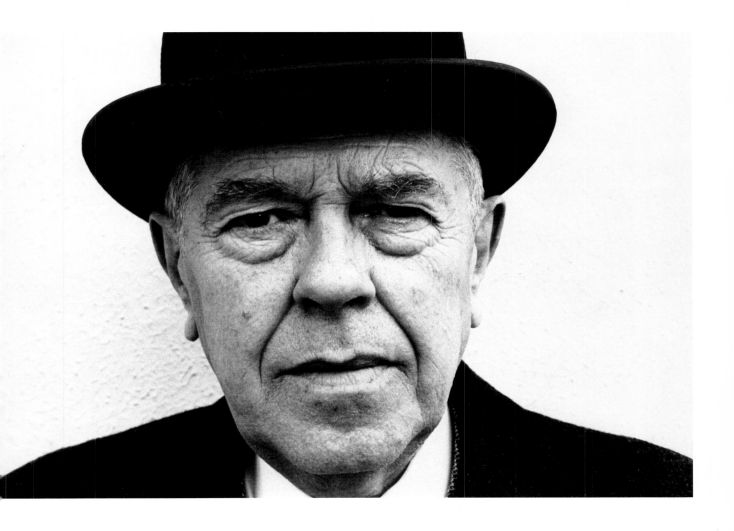

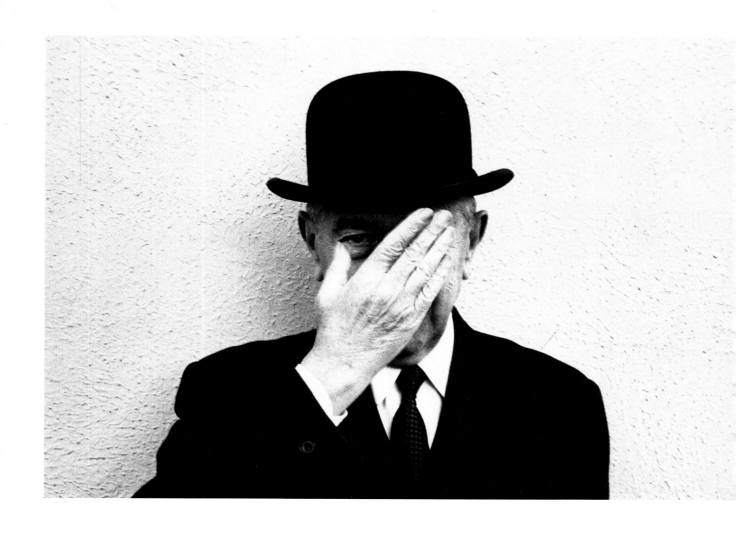

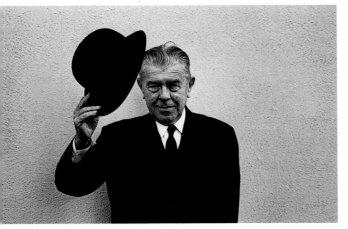 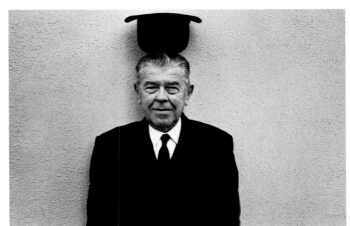

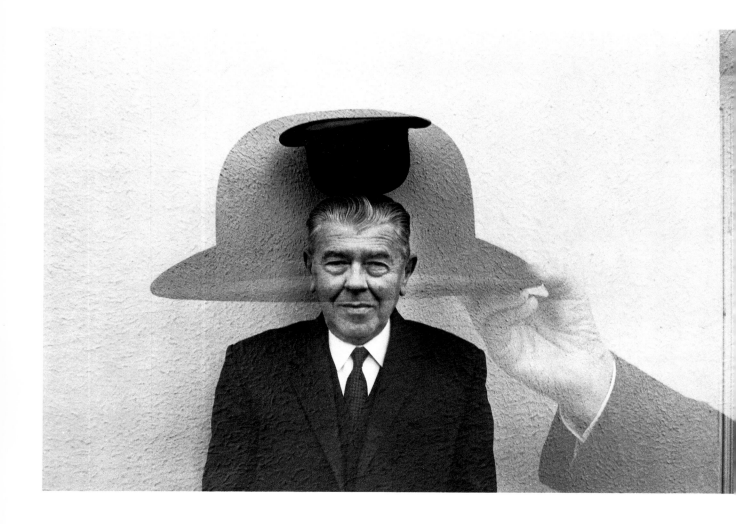

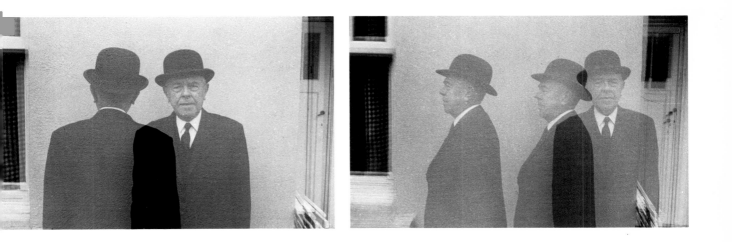

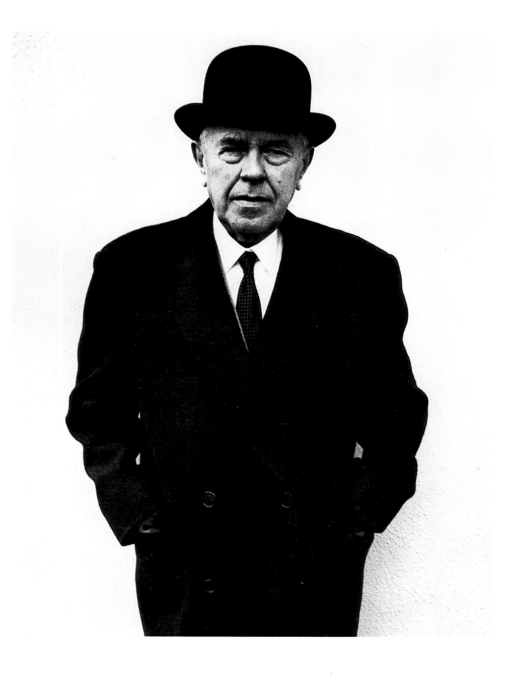

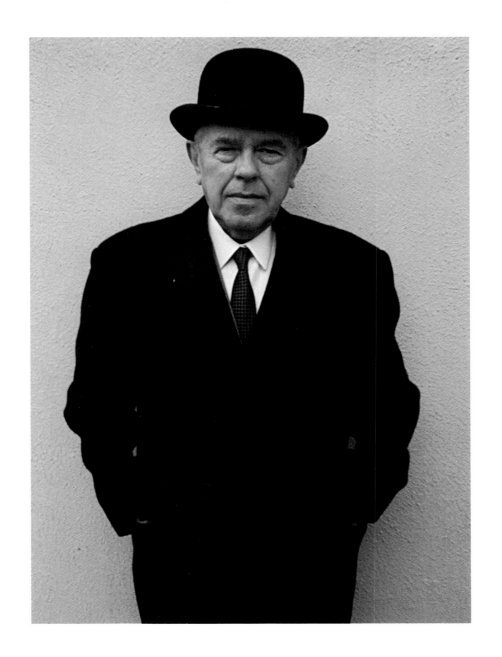

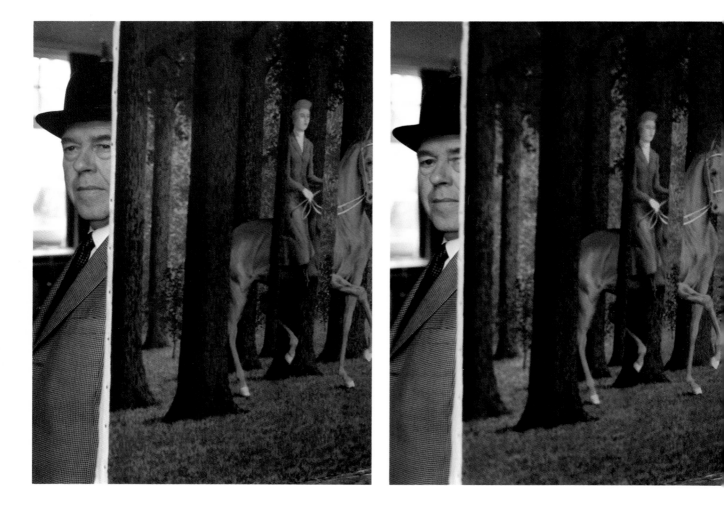

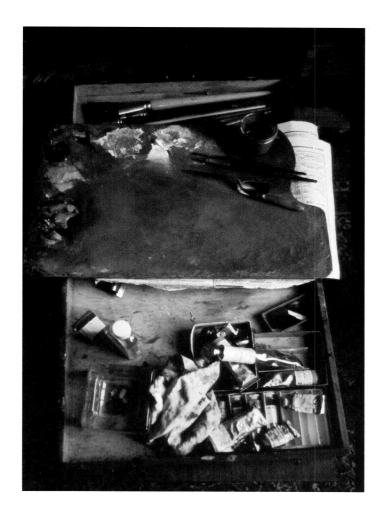

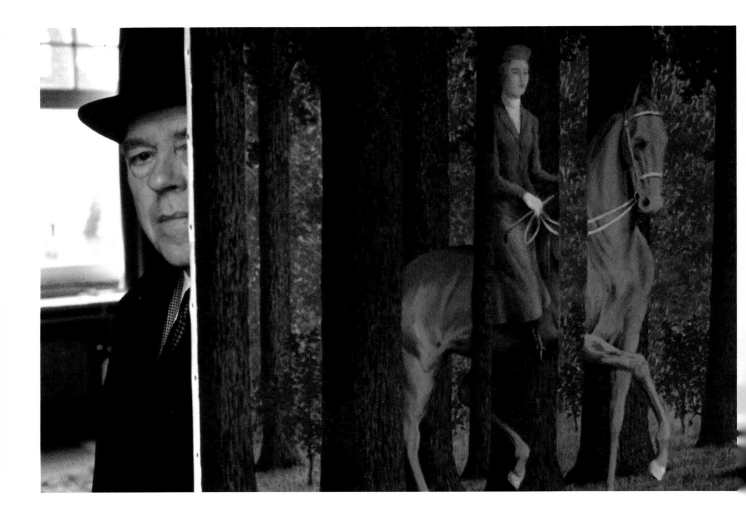

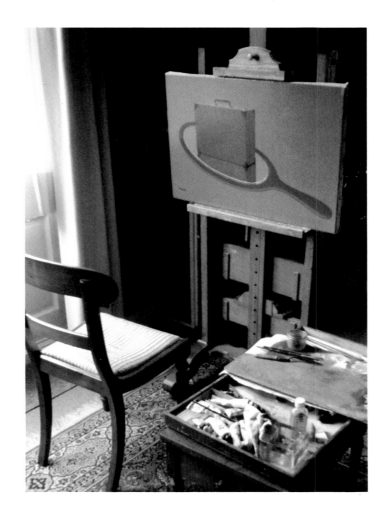

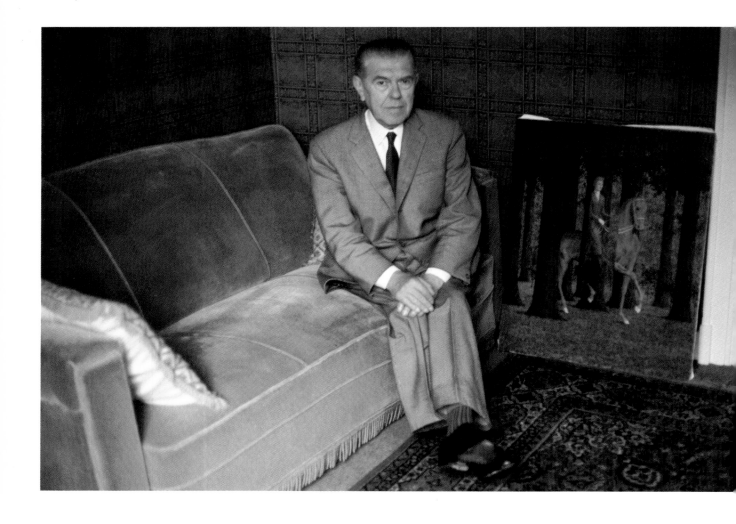

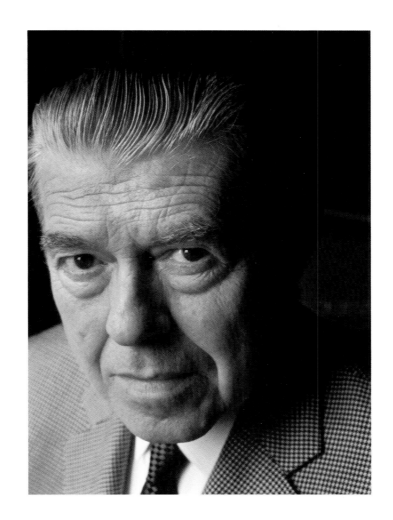

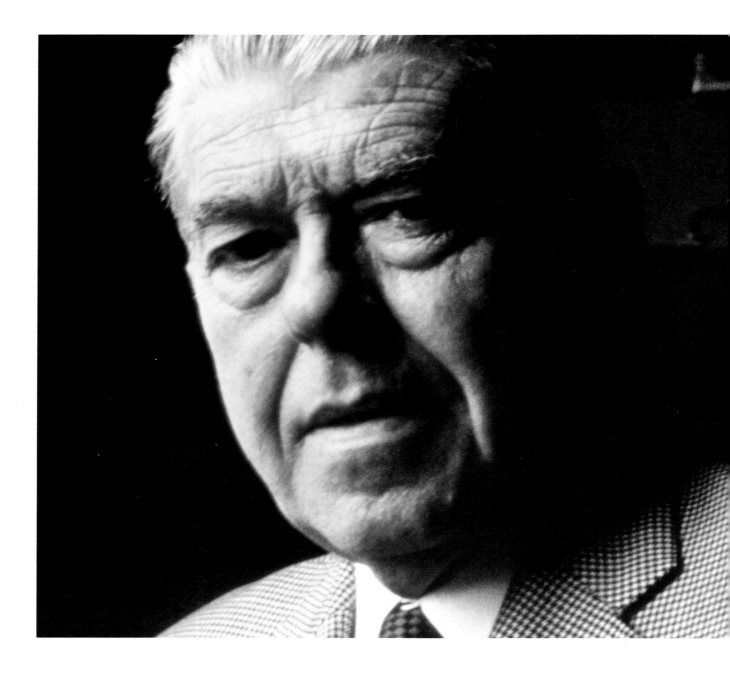

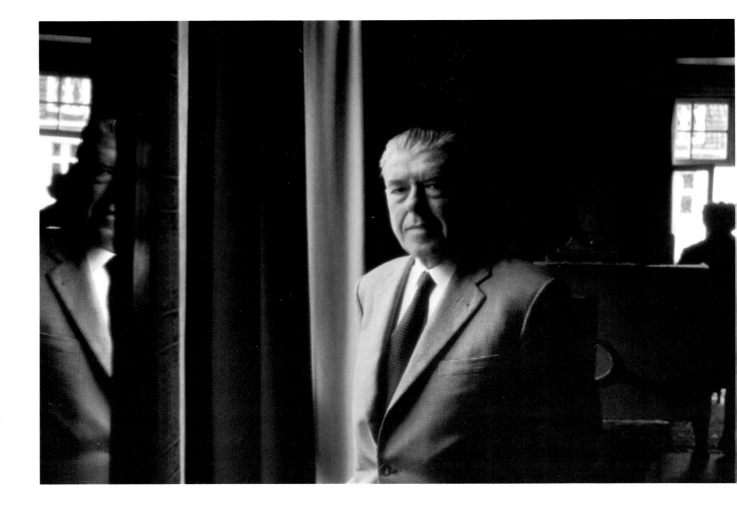

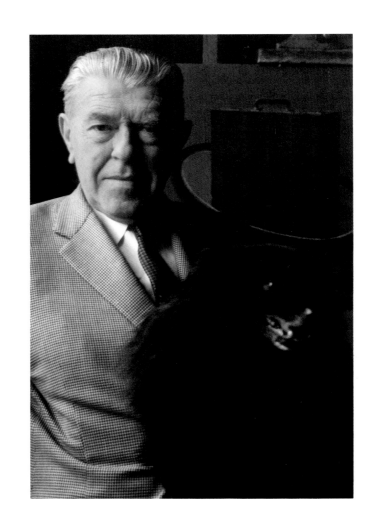

One would never guess that this was the true home of the domain of light. I was particularly interested in seeing Magritte's studio and at first walked through it without recognizing it. It was a small room off the bedroom with a green sofa, a comfortable chair and some bookcases. Everything was in order with the silent easel and palette being the only clues to what went on there. They looked like "smart" touches by a bad decorator. Although I never saw him paint, I suspected that he could be found at his easel dressed in the suit and tie he always wore. He was the familiar Magritte man.

On the afternoon that I said my last farewells to Rene and Georgette Magritte, I felt a sense of melancholy knowing that something wonderful had come to an end. A year and a half later, Magritte died.

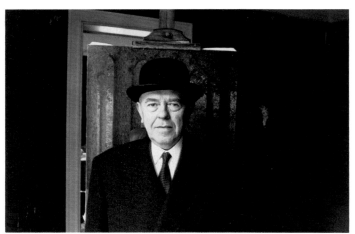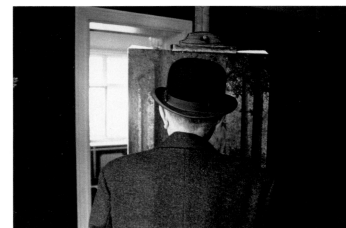

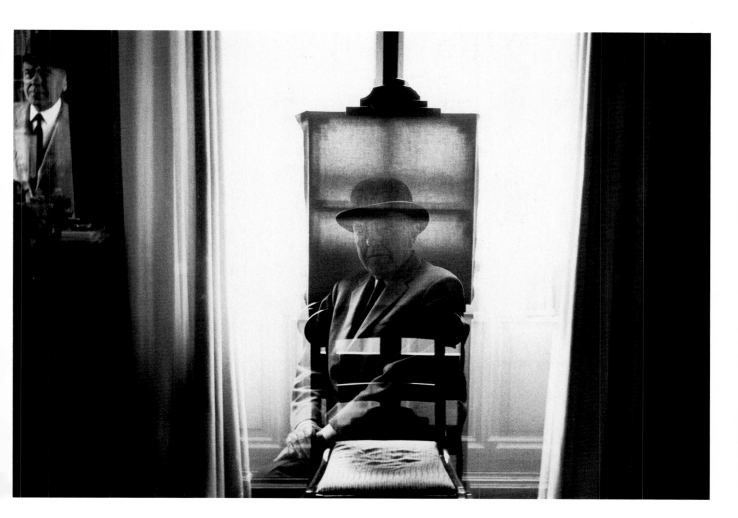

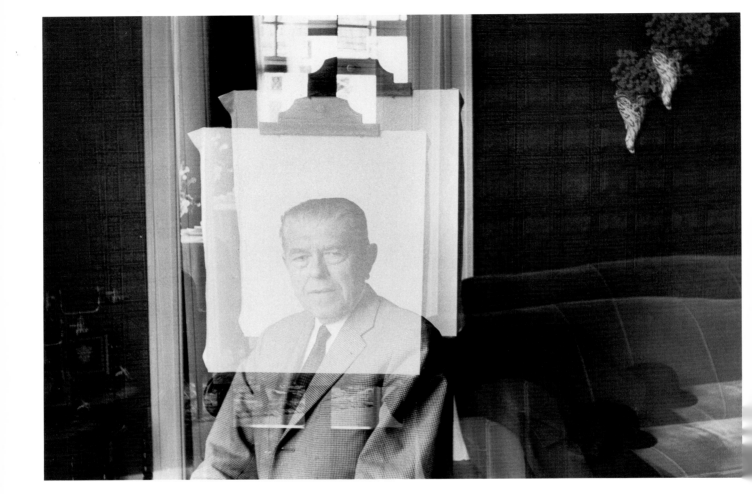

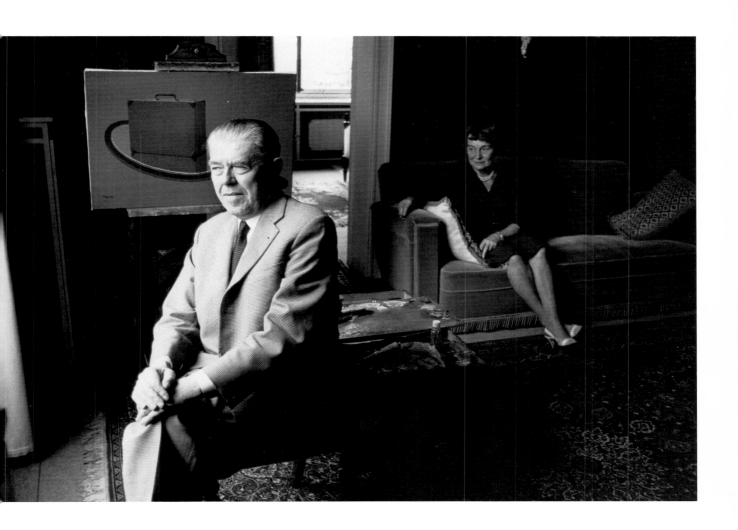

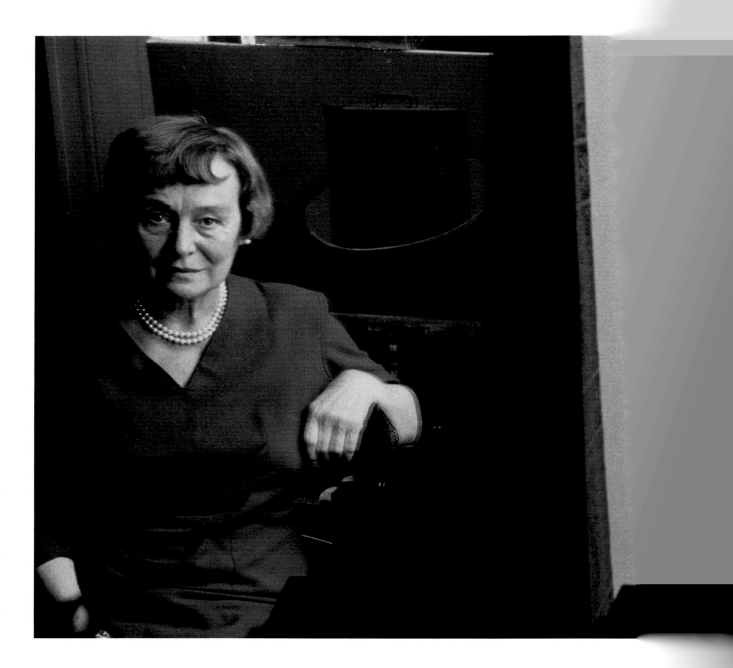

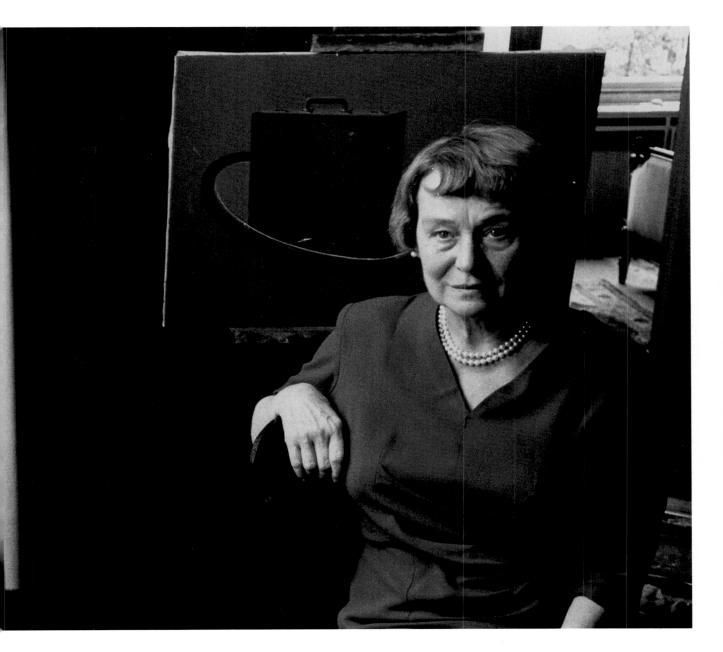

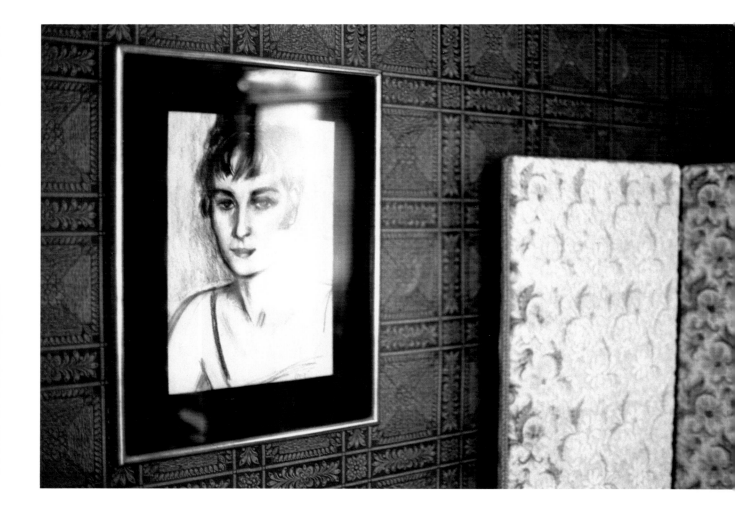

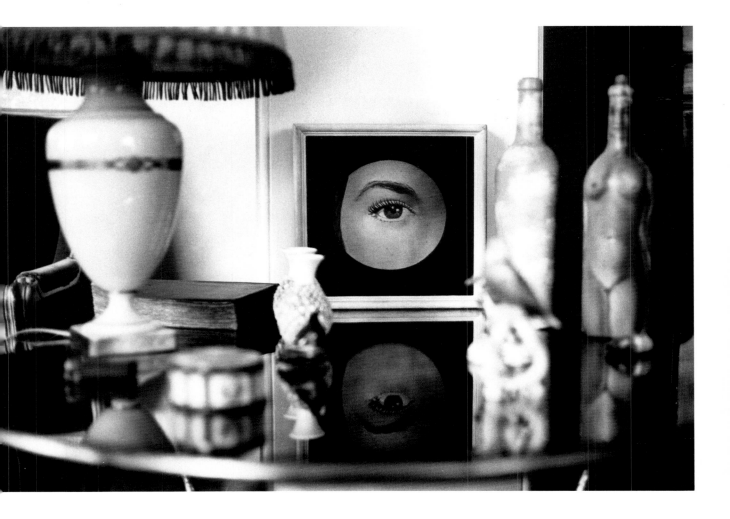

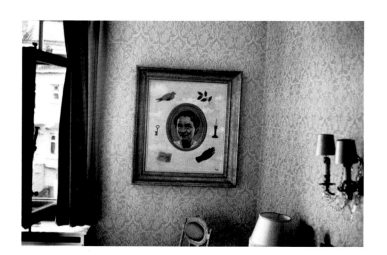

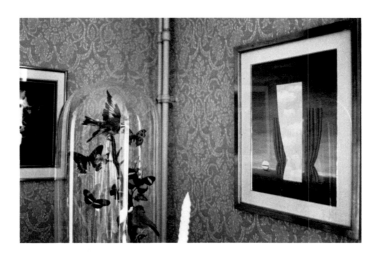

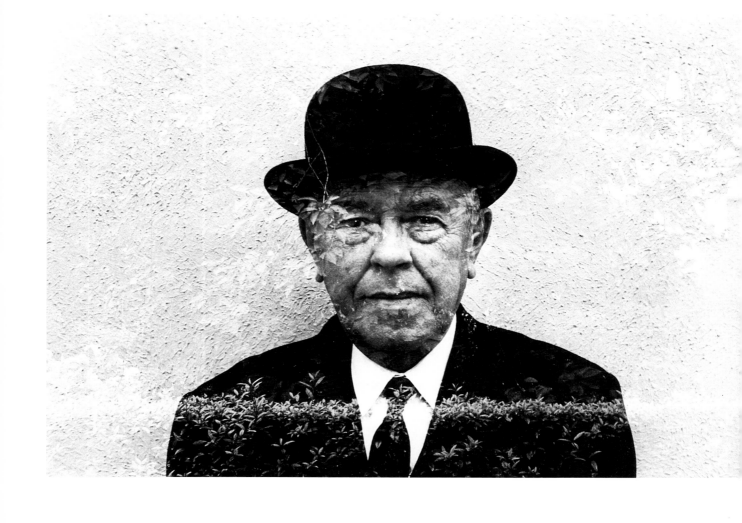

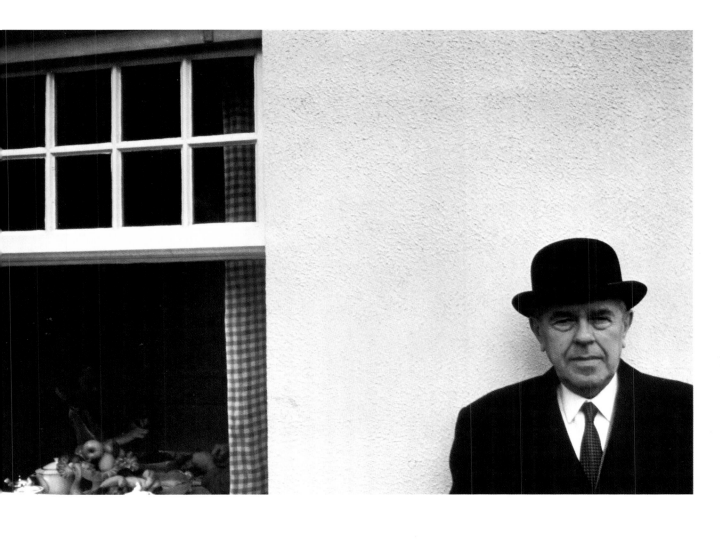

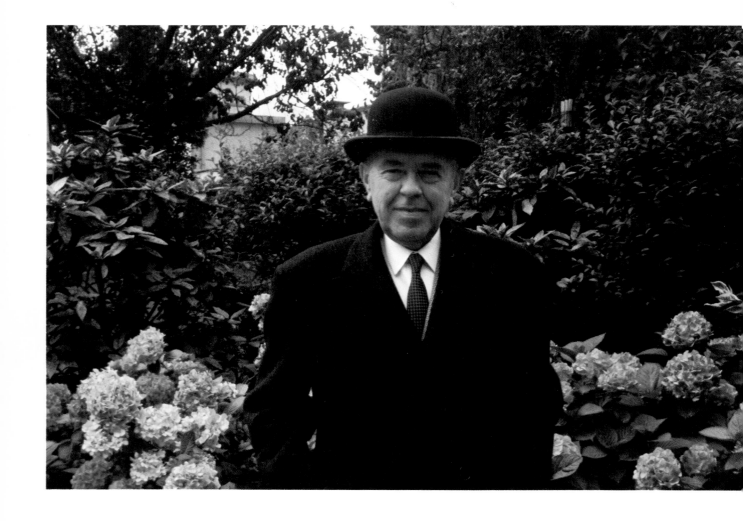

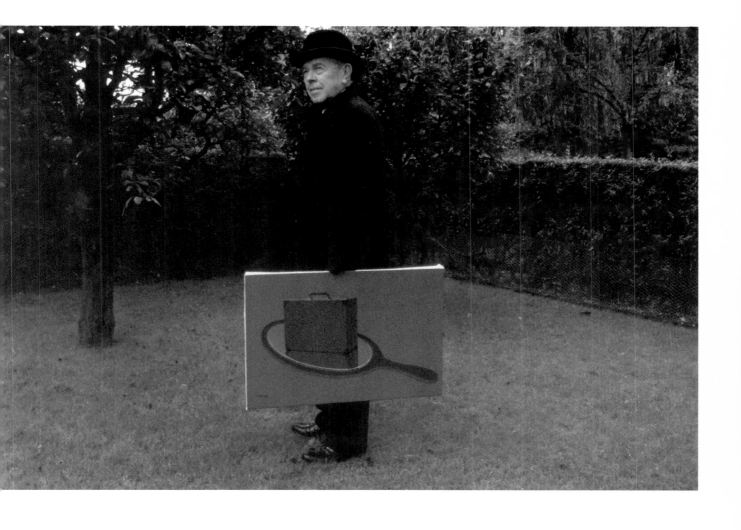

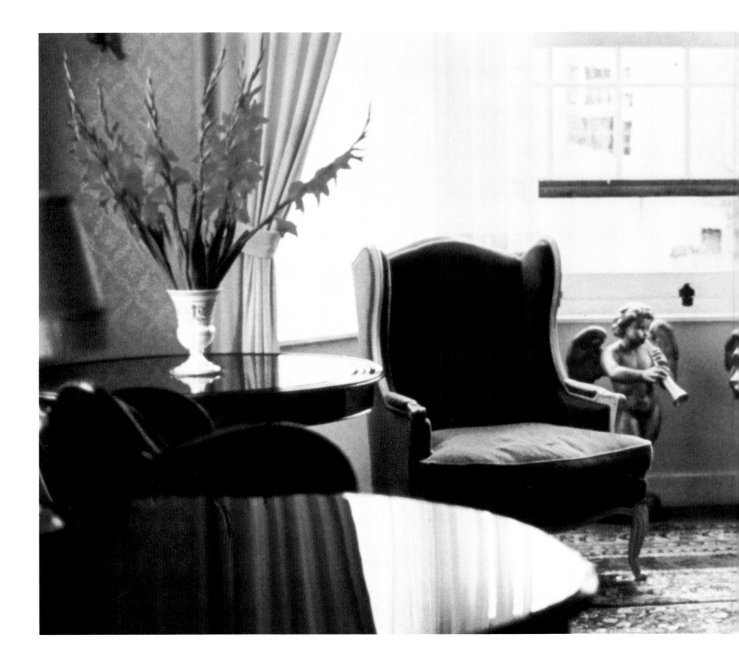

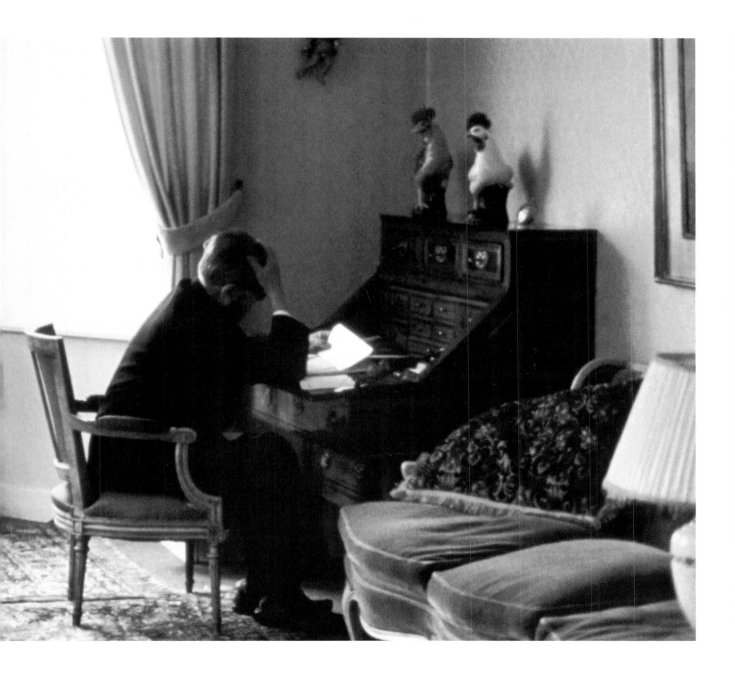

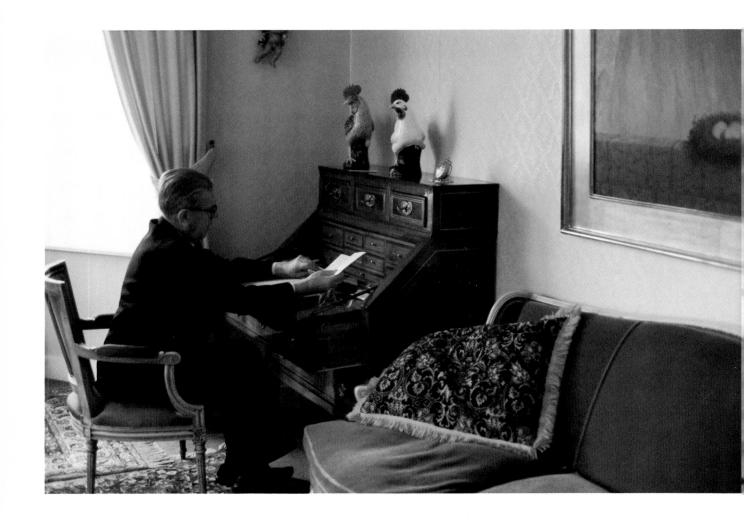

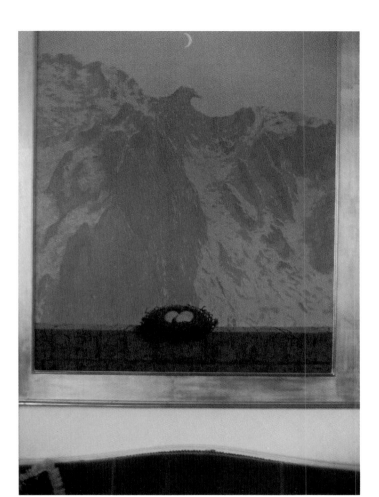

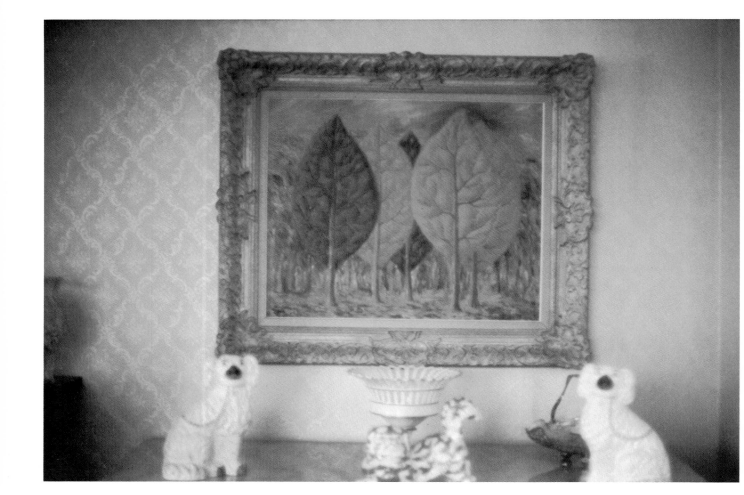

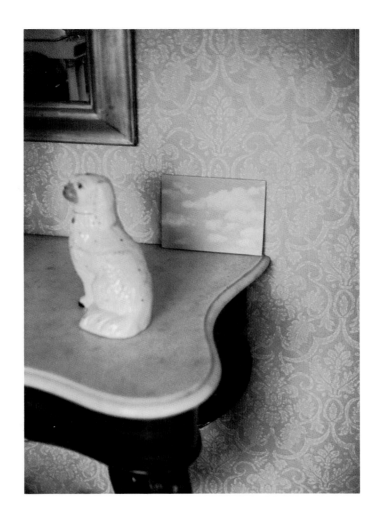

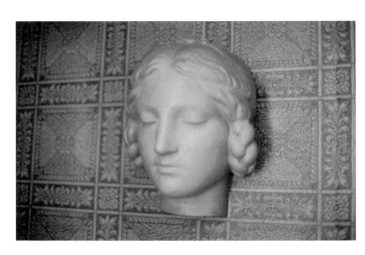

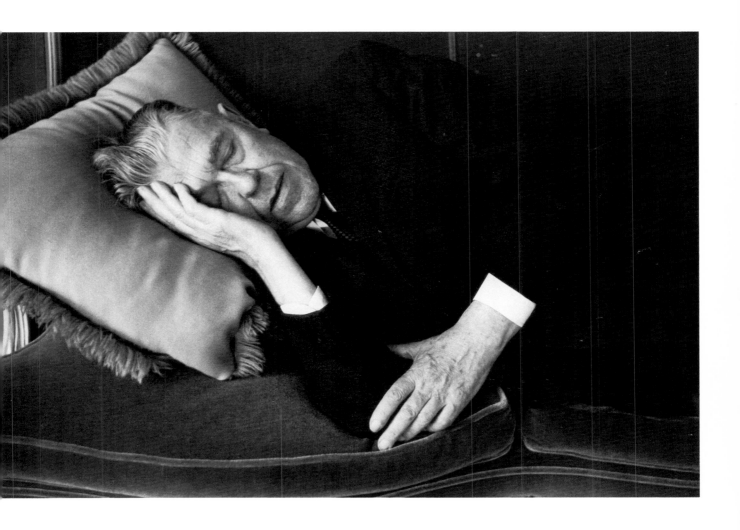

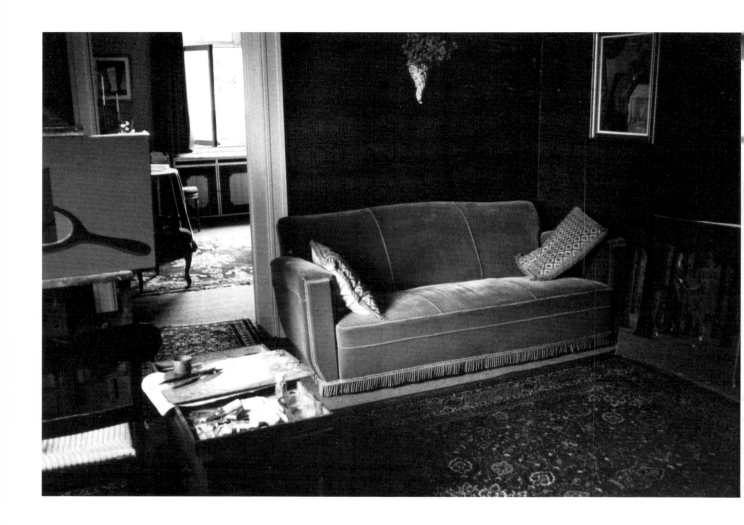

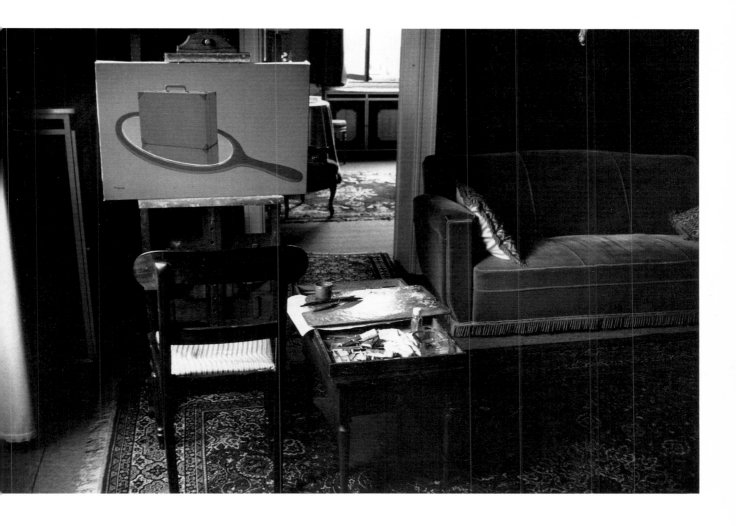

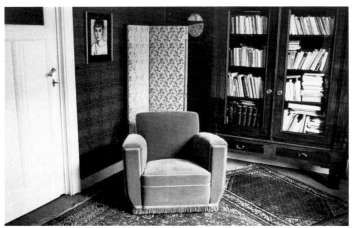

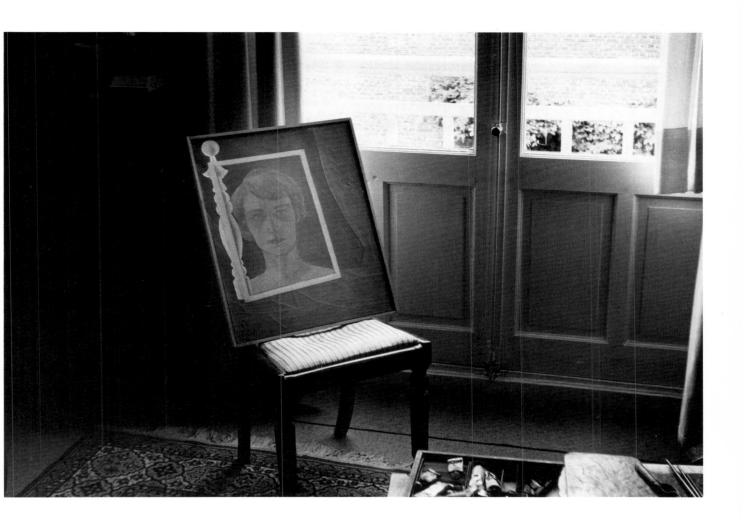

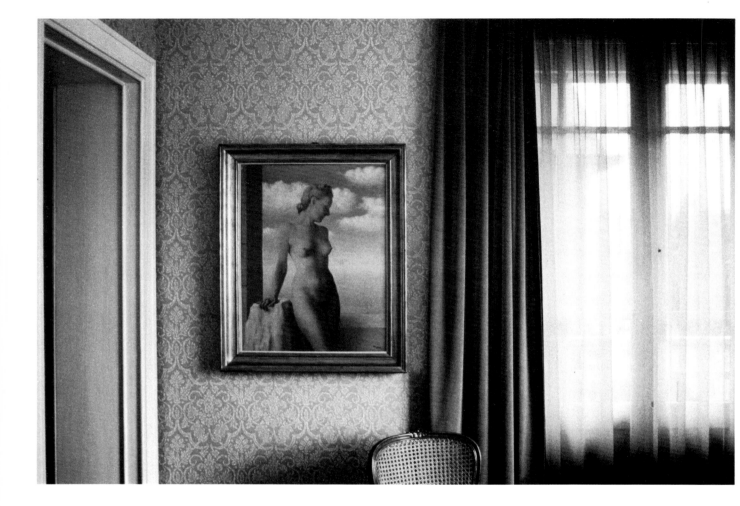

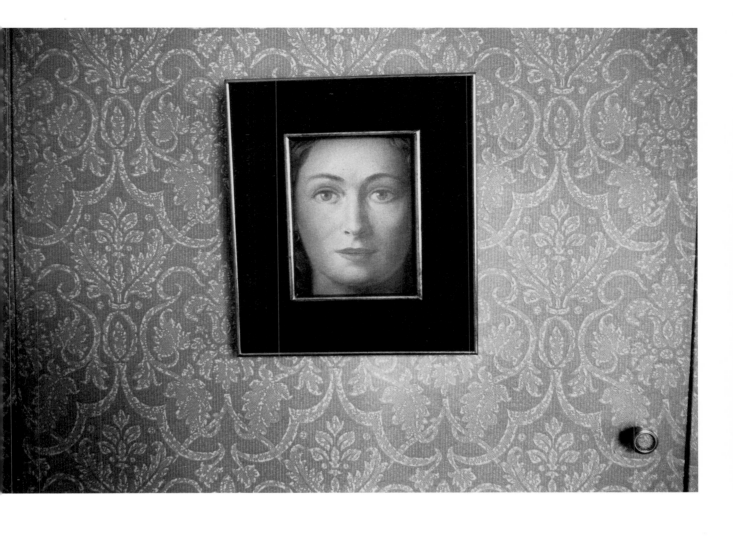

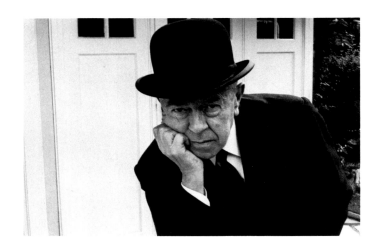

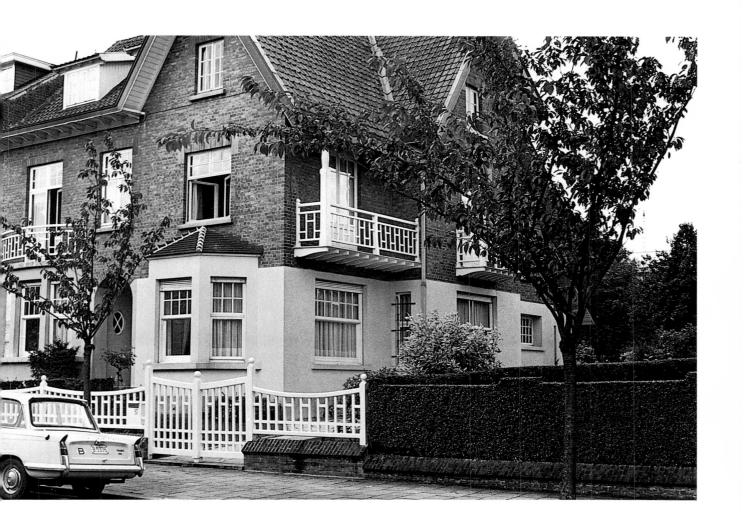

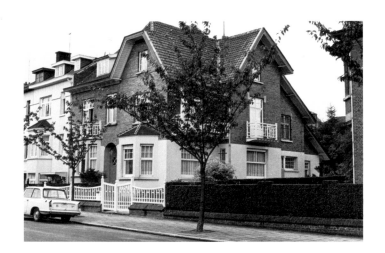

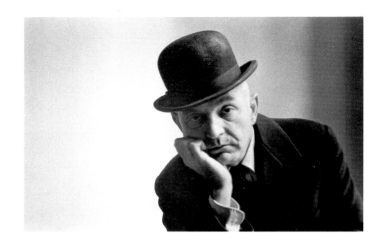

I am writing this sixteen years after going to Brussels, still
elated by the memory of my visit with Magritte.
What a fortunate man I am.

Dedicated to Georgette Magritte, the woman who shared
Rene Magritte's life and whose graciousness made this
book possible.

Published in the United States of America
by Matrix Publications, Inc. Providence, Rhode Island

Library of Congress Card #81-83658
International Standard Book Number:
0-936554-04-5 Cloth
0-936554-05-03 Paper

Printed in the United States of America

Edited by Charles Traub
Designed by Arne Lewis

Special thanks to Edgar Howard for the
conception of this book